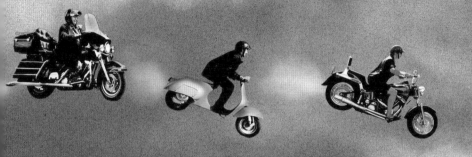

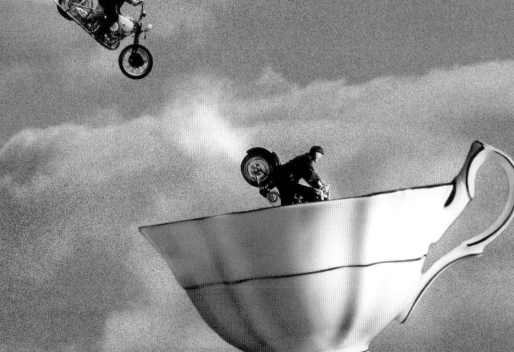

THE GRANNIES

A Tribute

to

Old Ladies

Who Refuse

to Become

Fossils

or Dinosaurs

or Leftovers

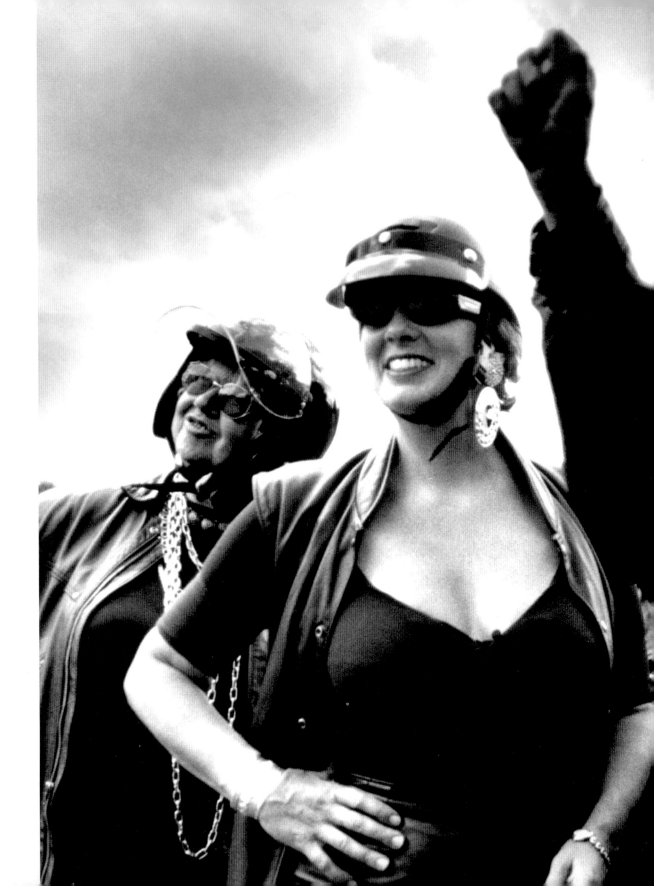

Ru'bicon

THE GRANNIES

story by Sybil Rampen *photographs by* Catherine Chatterton

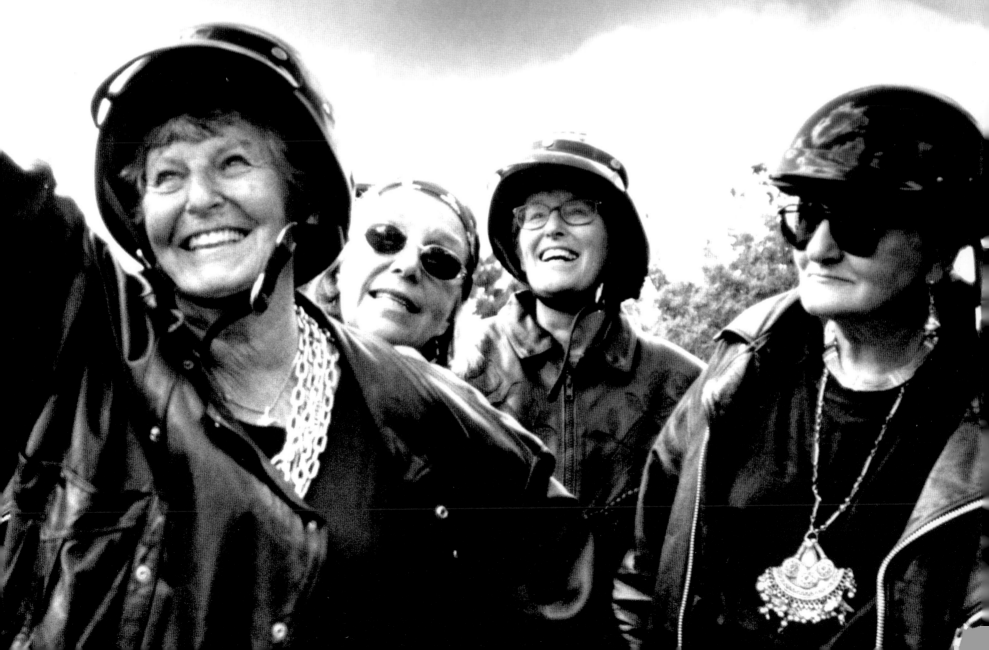

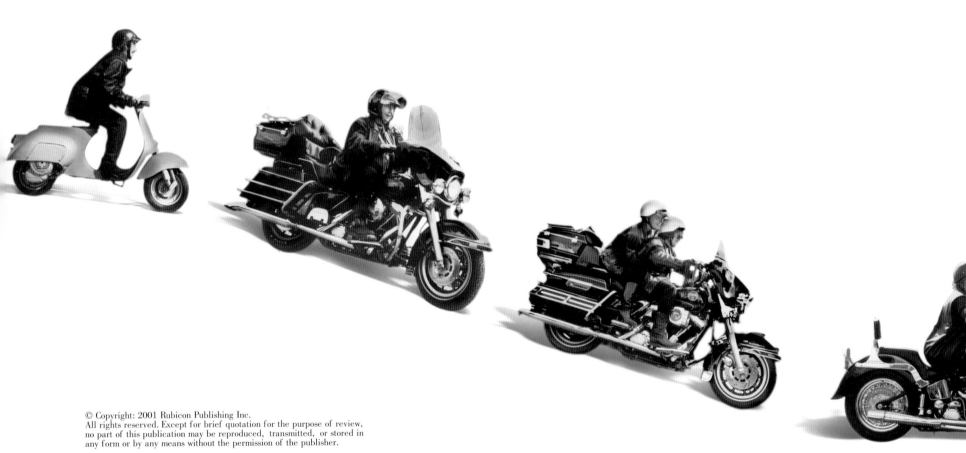

Designed by Catherine Chatterton

National Library of Canada Cataloguing in Publication Data

Rampen, Sybil
 The Grannies

ISBN: 0-921156-63-4

 I. Chatterton, Catherine II. Title.

PS8585.A4896H44 2001 C813/6 C2001-901413-9
PR9199.3.R256H34 2001

This book is dedicated to
Anita Mendel, who was my inspiration for "Methuselah."
- Sybil Rampen

For my parents, Betty and Wayne,
and my grandmother, Violet
- Catherine Chatterton

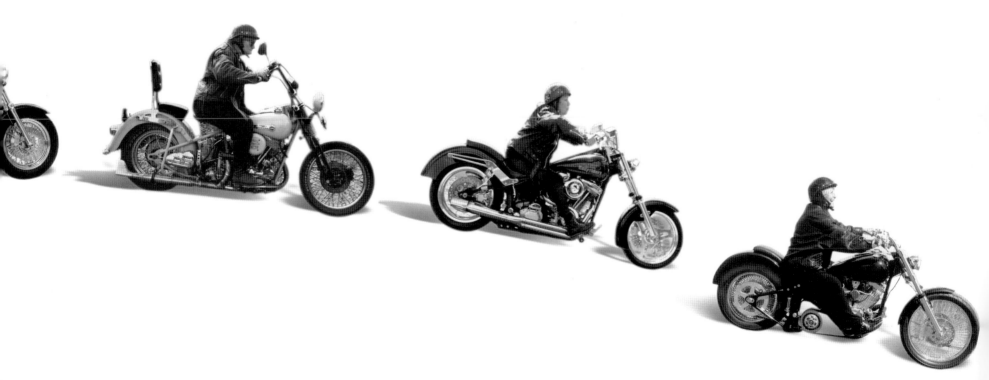

Contents

The Grannies

1

The Clubhouse

11

The Rocking Chair Band

19

The Wake

27

The New Leader

35

The Computer World

41

Grannies B.E. (Before Electricity)

47

Big Bertha's Story

55

Double Trouble's Story

61

Rosa's Story

69

Greta's Story

77

The Witch's Story

85

Able Mabel's Story

91

Methuselah's Story

95

A Word From the Author

All my life, curiosity has led me into strange places and challenging situations, and I have had the privilege of meeting extraordinary friends. All of these experiences and people are entwined in this story, which began when a woman came to my studio one day and asked if I would stitch a motorcycle figure to celebrate her first wedding anniversary. I said no, but I would show her how to make her own using the cucumber pods that grow beside my pond. I did, and the filigree figure of "Methuselah" arrived on her iron steed. Six more ladies on motorcycles followed in quick succession.

Someone suggested I write stories about these Grannies, stitched from natural materials. I did. Writing the story was like following a paper trail or unravelling a ball of wool. After eight chapters, I tried to write "The End," but the story wouldn't end. So I kept on writing.

When the word processor moved into my life, each Grannie became a separate entity, her story drawn from my own memory and experience. "Methuselah" was really Anita, my friend since we were both 12. When I rang Anita in London in 1998, she answered, saying, "How did you know to phone me now? I've just finished swimming the Channel and I think I've done myself in. The ambulance is coming." She celebrated her birthday on May 5th with a big cake at the hospice and died four days later. I stitched "Anita Going to Heaven on her Bike Surrounded by Six Angels," in her memory. Anita's whimsy, outrageous behaviour, and courage can be felt throughout this book.

Maggie Goh of Rubicon Publishing became interested in the story. She showed me a photograph of a nun on a motorcycle, taken by a young photographer, Catherine Chatterton, and suggested we work together. I offered to play the role of "the Witch" and to round up my friends to pose as the other Grannies. We met Ron Doyle of Easyriders in Cambridge, Ontario, who transformed us into bikers — and we became "The Mob." We trailed after Cathy to many locations: we donned leathers, mounted motorbikes, knitted under mountains of wool, drank tea, sang and clanked with old instruments, and floated in a hot tub in bulgy bathing suits. At first we were stunned by our photographer/director who had fixed ideas of what she wanted. It was hard work, but the more we did our "mean," "perky perky," "wise," expressions, the more we became our characters. A sense of the ridiculous took over reservations of propriety and we began to rollick through the photo sessions like well-trained seals. Whenever we see each other now, we giggle and laugh, not at each other, but at life.

The End... *or is it?*

Sybil Rampen

And From the Photographer

We started from scratch with a bunch of sweet, unsuspecting Grannies and by the end of it all they were transformed, and so was I. The author, Sybil Rampen, had asked her friends to pose as the Grannies — and they proved to be a gang of gutsy Grannies, unafraid to take on anything! From our very first meeting — over tea — these warm souls welcomed me into their clan with open arms. As we worked together, I began to see the depth and strength of their spirit.

The Grannies had no idea being models would be such hard work. It took a lot of directing, but they delivered! By the second shoot, they actually began to display the personalities of Able Mabel, Big Bertha, Double Trouble, Greta, Methuselah, Rosa, and the Witch. All my other "models" — Mary and Baby, the brides and grooms, and the chicken farm kids — were equally wonderful.

As a 23 year-old woman, I was inspired by the spirit, courage, and humour of the Grannies, who ranged in age from 52 to 82. What a great experience it was to be able to work with people on the same wavelength, and then sit back and realize that we were from totally different generations! I think it was rewarding from both sides — we each worked to bridge the gap between the generations and we experienced something none of us will ever forget. The Grannies helped me to find the wisdom that was within me, and I helped to bring out the youthful vitality that is still throbbing wildly within them.

I can't say enough thank-yous to Ron Doyle and his team of friendly biker giants from Easyriders of Ontario. Ron not only supplied the Grannies with motorbikes but also decked them out in leathers, helmets, and other biking paraphernalia from his store. Then he and his fabulous team of guys and gals trucked out with us in the wee hours of the early morning to help set up the motorbikes and teach the Grannies to "ride" them! Without their hard work, pure good-nature, and bemused curiosity about the project, we would never have been able to capture the incredible shots.

It was so exciting for me to see each character come to life. For a photographer, watching something you imagine in your head and draw out in your mind become a living, breathing picture is a truly incredible experience.

The most important lesson I've learned from my encounter with *The Grannies* is that there is a bit of all of these fearless grannie characters within us all.

Catherine Chatterton

THE GRANNIES

Once there was a bunch of old women
who lived in a Home
and got *fed up* with being leftovers.

Over a cup of tea,
they discussed the problem and decided
they just *had* to do something.

Methuselah: "After all, we aren't dead yet."

And they all agreed.

 Big Bertha: "I used to ride a mule over the mountains."

 The Witch: "I rode a bicycle."

The Twins: "We were mud wrestlers."

 Rosa: "I had 13 children and raised 'em on a chicken ranch."

Greta: "Once I ran away with a circus."

Stay-at-Home Mabel: "Well, I stayed home and looked after my folks.
Oh dear, I wish… I wish…
I could *do* something!"

So the Grannies looked and searched for
something to do as a group,
but there was nothing,
only knitting.

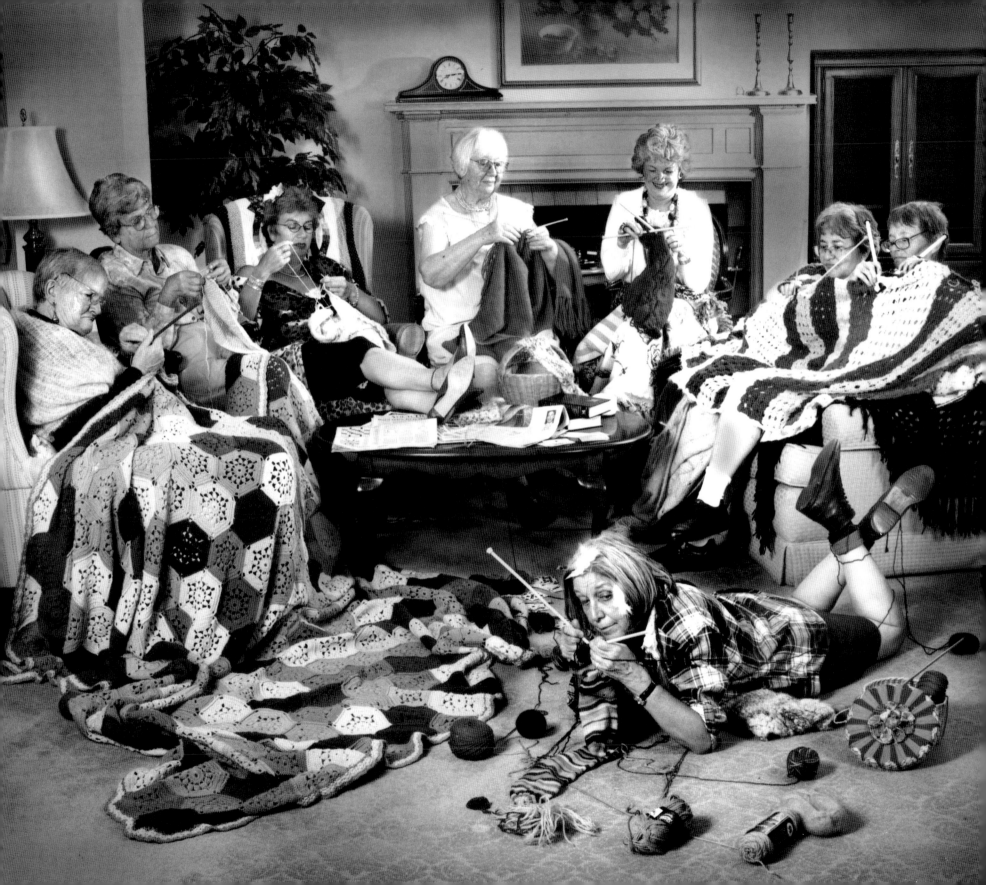

One day, Methuselah
(who was the oldest and the leader)
happened to notice in the paper
a course in Auto Mechanics
at the local high school,
and they all signed up.

The instructor was a little puzzled
at having eight old Grannies in his class,
but he was willing…

The kids didn't seem to mind.
In fact, they began to take more interest
and make more effort
to keep up with "the Mob"
as they called them.

The Grannies learned to change tires.
Big Bertha could loosen tight bolts.
The Witch had a knack with brake pads.
Double Trouble were amazing with manifolds,
and Rosa and Greta were great on carburetors.

They all looked forward to their day at school.

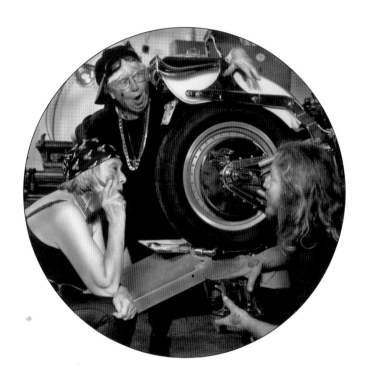

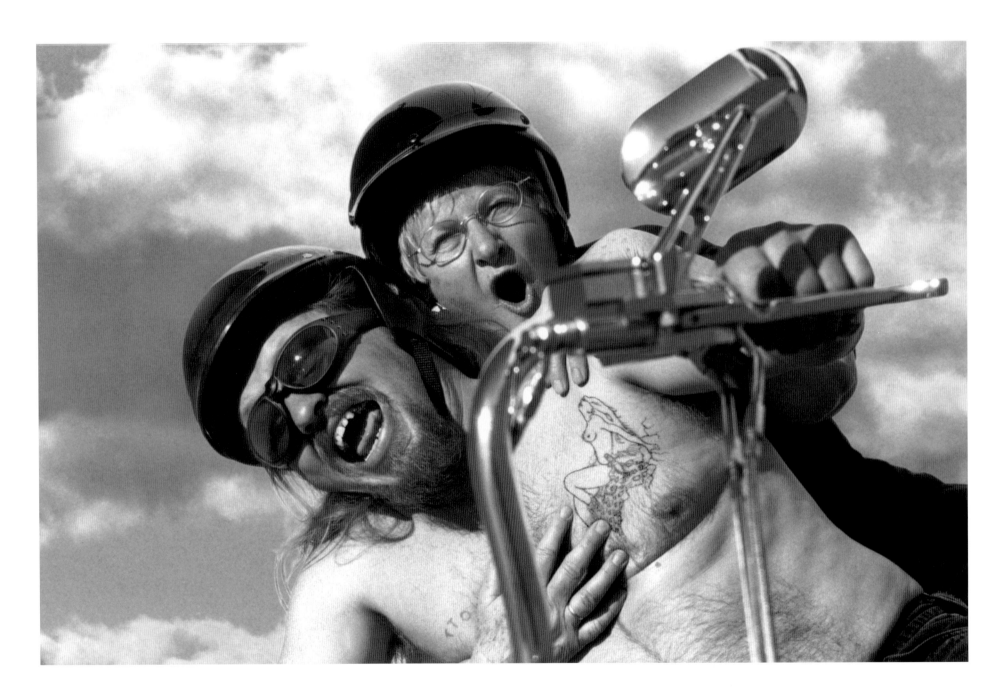

One day, the Witch was invited by Big Joe,
a friendly, tattooed giant,
to hitch a ride home
on the back of his motorcycle.

"It was like going to Heaven!"
she shouted.

All the Grannies looked at one another
and made an "O" shape with their mouths.
"Motorcycles!" they breathed,
and one by one they begged a ride home with Big Joe.

He was a kindly fellow who laughed and laughed
at the idea of flying through the streets
with an old lady clutched on behind…
until they asked for lessons!

But by this time he had grown fond of them…
and he agreed!

Over a cup of tea,
all the Grannies had the same IDEA:
"Let's put our money together
and buy a shiny new motorbike!"
And they did.

First Methuselah got her licence
(because she was the oldest)
and then they all did,
well *almost* all,
for Double Trouble got one between them.

Then, just about that time,
Big Bertha inherited some money.
What to do with it?
They all shouted:
"Buy a whole fleet of shiny new motorbikes!"
And she did.

Methuselah: "Now we can all go riding,
feel the sun and wind in our faces,
and see the world."
And they did.

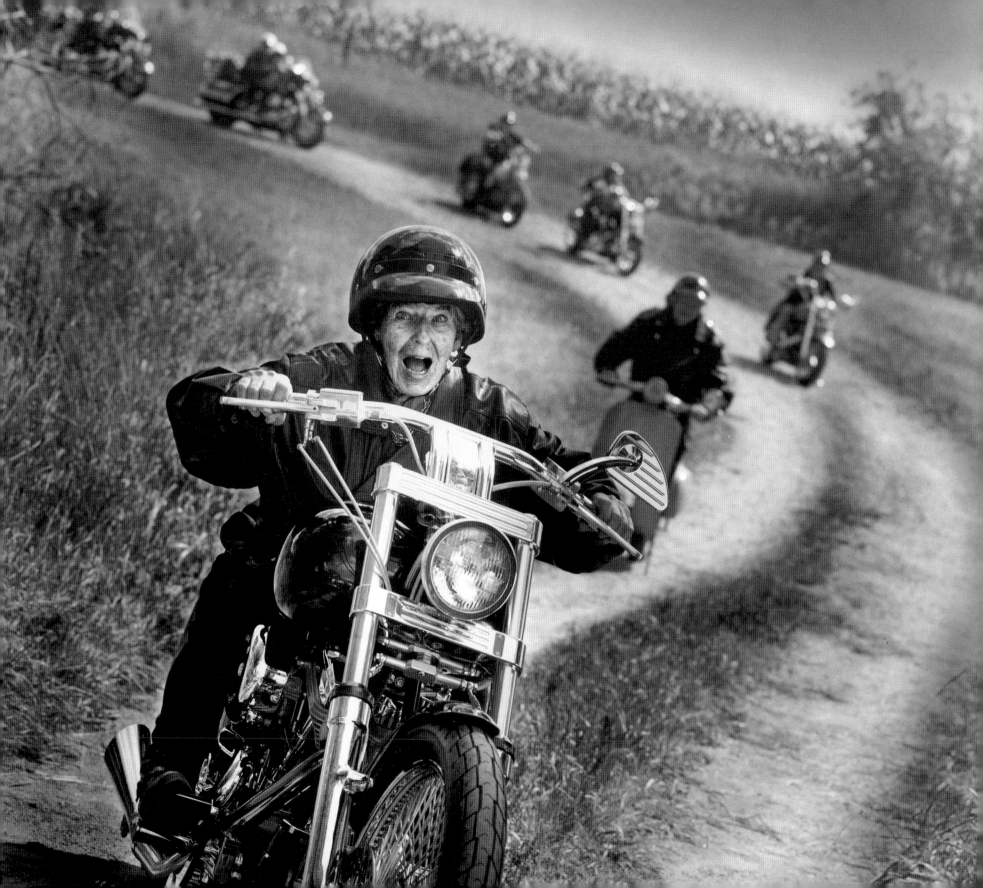

THE CLUBHOUSE

One day, after a particularly fine ride,
the Grannies sat chatting
over a cup of tea.

Methuselah: "I saw a white horse on a carpet of red clover."
Big Bertha: "I saw a green hill covered with red cows."
Double Trouble: "We drove past a field of white turkeys,
looking like flower blossoms."
Stay-at-Home Mabel: "Well, I saw an entire clothesline of diapers.
No Pampers there!"

And together they chimed:
"Isn't the world a beautiful place...
but... if only... if only...
we had a spot of our own."

Suddenly, all their eyes popped open
with an IDEA!

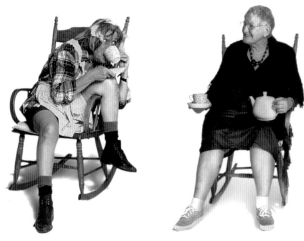

"Let's get a clubhouse!"
"Just for Grannies!"
"Not too far, but not too near."
"With enough room to tinker with carburetors…"
"And make tea…"
"And keep a chicken or two…"
"And plant petunias…"
"And… and…"

And they all agreed.

After that, whenever they went riding,
the Grannies kept a sharp eye out
for just the right kind of building.

Soon they had explored almost every road,
even the gravelly ones,
but they found nothing.

Sometimes they packed a picnic,
parked their machines, took off their boots,
and paddled in a stream.

Sometimes they just sat quietly in the grass
and listened to the sounds of the country,
the crickets, the birds, the wind in the trees.

And all the time
they dreamed about a clubhouse.

They looked and they looked,
but found nothing.
And they almost gave up their dream.

Then one day,
after a fine roar down a tiny road,
they spotted a little barn standing in a field.

In one motion the entire gang skidded to a halt.
"*Yes!*" they cried. "This is it!"
"It's private, it's accessible…"
"But who owns it? Can we rent it?"

They drove up to the farmhouse to inquire.
It was way back from the road,
and they could see
a clothesline of flapping diapers.

The farmer's wife was a little startled
to see a gang of motorcycles
coming up her long lane.

Her baby was awakened by the noise
and began to cry.

What a surprise when the bikers dismounted
and took off their helmets!
Old ladies on motorbikes?

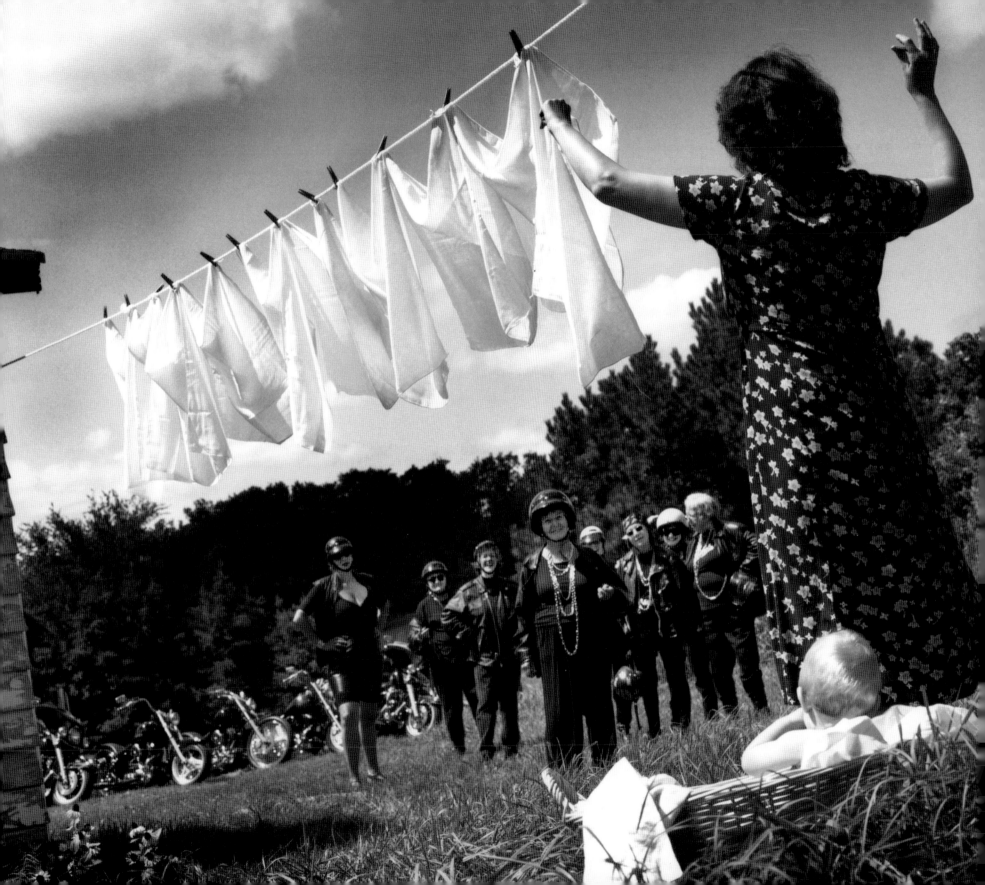

Methuselah introduced everyone,
and so Mary, the farmer's wife, met
Big Bertha and Double Trouble,
The Witch, Rosa, and Greta,
and Stay-at-Home Mabel,
and they all gave her tips on crying babies!

Then they told her about their dream
of having a place of their own
and how they had fallen in love with the little barn.
She promised to discuss the matter with her husband
when he came home from the fields for supper,
and she did.

He, wise man that he was, thought how nice it would be
for his wife to have company and his baby to have many grannies.
"It's only a little barn," he chortled, "built by the pioneers,
but I kinda liked it and mended the roof...
but... I guess I could rent it to you."
And he did.

And so it came about that "the Mob"
had a spot of their own,
and their dream became a reality.

It is surprising what eight determined Grannies can do,
especially when they belong to the make- do generation.
They had what in the olden days was known as a "bee."
They piled all the cobwebby contents into the granary
(where the pioneers stored their grain at harvest time).
They swept and tidied, and sang funny old songs.
They fixed the windows and they polished them.
They sawed and nailed old boards into benches.
They scrounged furniture from their families,
and hunted for tea cups at garage sales.
Finally, their clubhouse was ready
and the Grannies sat down
for a cup of tea.

Methuselah spoke for all of them when she said,
"Here we are in our own place at last."
The Grannies chimed in:
"It's not too far, it's private, and we *love* it."

They even made a sign:

THE GRANNIES CLUBHOUSE

THE
ROCKING CHAIR BAND

All summer, the Grannies rode to their clubhouse.

Whenever Mary, the farmer's wife,
heard the roar of their arrival,
she would hurry over with the baby,
bringing cookies and lemonade.

On fine days, the Grannies
tinkered with their bikes, planted petunias,
drank tea, and played with the baby.

One day, over a cup of tea, they pondered:
"What do people *do* in clubhouses?
We've never had one before."

Mary, the farmer's wife,
quietly offered a suggestion:
"You could make NOISE."

The Grannies looked at one another
as an IDEA hit them again!
"Let's make our own band!"

Methuselah began to sing
"Roll Out the Barrel,"
and they all joined in, baby too.

They caterwauled away and got so excited
they almost fell off their chairs.

Rosa: "I used to have a lovely voice."
Double Trouble: "We sang in a church choir."
Big Bertha: "I was a drummer in a bugle band."
Greta: "I played the mouth organ."

Stay-at-Home Mabel: "But we don't have any instruments."

The Witch: "That's no problem.

We can make them from what's around."

And they did.

They sawed the handle of a broken shovel into lengths.

When hit together, they made a lovely hollow sound.

"How about gravel in a cocoa tin?"

"Listen to that rattle!"

"Let's hang this old plough shear and see how it sounds."

They hit it with a tack hammer and took turns clanging.

"I can make a drum from an old saucepan!"

"What about cymbals from these lids?"

Gradually each Grannie settled on a favourite instrument,

experimenting and practising

until she could ride it like a motorcycle.

To keep the beat they chanted:

"Car-bu-re-tor, car-bu-re-tor,

man-i-fold, man-i-fold,"

going faster and faster

like a choo choo train.

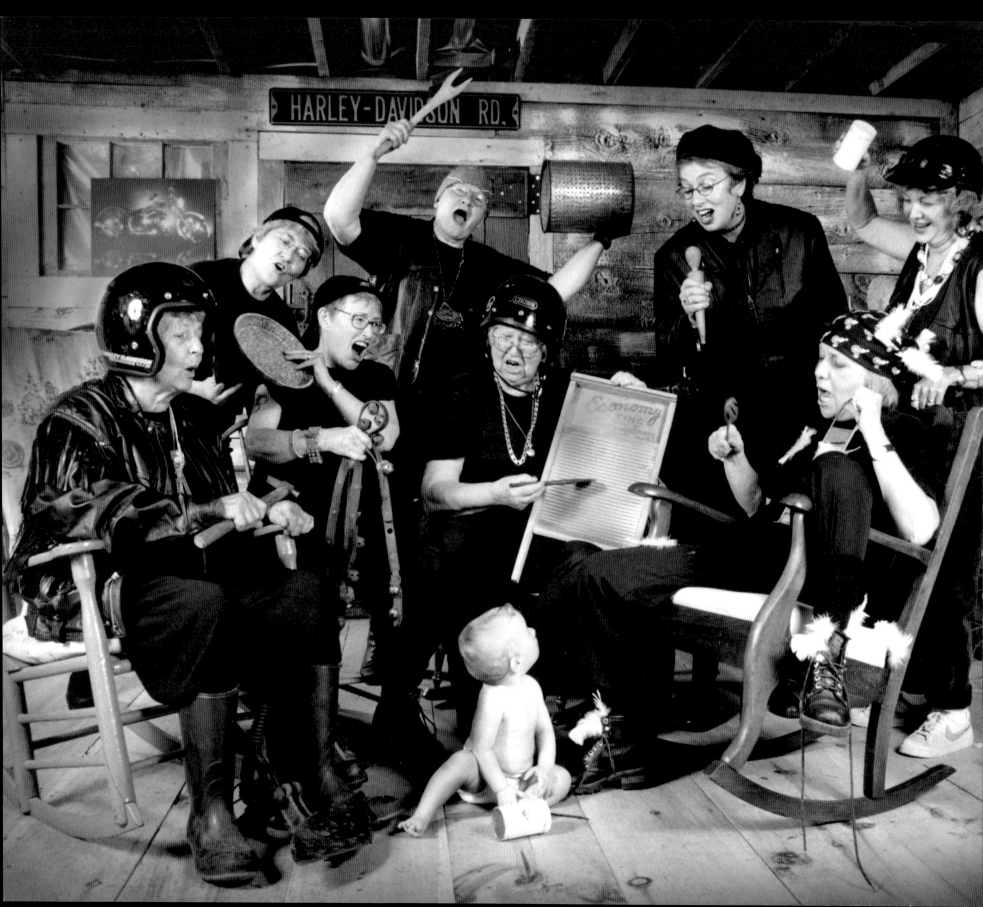

At first the noise was horrific,
but the Grannies were having so much fun
they didn't notice.
When it was too loud they simply put on their helmets
and Mary and the baby would leave,
giggling all the way home.

Soon the Grannies composed some numbers,
combining words and sounds.
They tried them out on their friends in the Home.
The audience was overwhelmed by the strange sounds
but soon caught the beat of the road,
and joined in by clapping.
They asked for more and more.

A newspaper heard about them and wrote them up.
They played on the radio on a program called
"Sounds in the Country."
They even cut a CD.
And a television crew
came to the clubhouse to film them!

With cameras trained on them,
the Grannies swooped up the lane on their motorcycles
looking like true knights of the road.
But when they dismounted (a little stiffly)
and took off their helmets…
they were just eight old ladies.

In single file, they entered the barn
and headed for their instruments.
Methuselah raised her tack hammer
and they began to play and sing.

At first the Grannies were self-conscious,
but they soon forgot the cameras and became wired,
and the little barn jumped with joy.

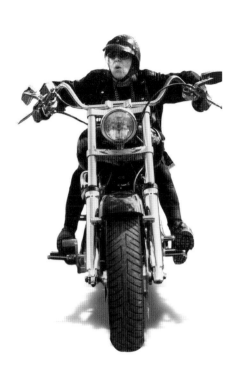

The Grannies played and sang till
everyone was exhausted.
Then, over a cup of tea,
they listened with great pleasure to the comments.

"What a strong beat you have!"
"What remarkable stories you tell!"
"What an unusual combination
of clang, bang, and lyrics."
"What strange instruments!"
"It's so endearing!"
"A piece of history!"

After tea, the Grannies roared home to rest.
And Mary, the farmer's wife,
was so happy with her new friends
that she added another line to their sign:

THE GRANNIES CLUBHOUSE
***and* ROCKING CHAIR BAND**

THE WAKE

One evening,
as the Grannies were having their tea,
Methuselah began to make plans for the winter.

"September is coming.
We should look into another course
at the High School.

Motor Mechanics was such a success,
let's find other courses
that would be suitable for Grannies.

Also, we must think about
storing our machines for the winter.
It's always good to be prepared."

And they all agreed.

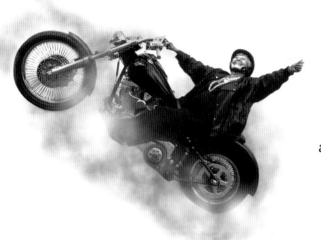

But they were not prepared
when Methuselah left them late one night.

She slipped quietly away
as the full moon rose and the stars came out.
She rode her motorcycle to Heaven,
accompanied by six angels.

Her life had been long,
her leadership wise and gentle,
but her departure was sudden
and her friends were sad.

Big Bertha: "She did everything she wanted to."

The Witch: "Without her we would still be knitting."

And they all looked at her empty chair sorrowfully.

Next day, the weather being particularly fine,
the Grannies headed for their clubhouse.
They drove their machines so slowly and quietly
that Mary almost didn't hear them…
but she did… and noticed immediately
that Methuselah was not with them.

She too was saddened by the loss.

"How can we say goodbye to her?"
asked Stay-at-Home Mabel.

"What about a Wake?" suggested Mary.
"A Wake is a goodbye celebration.
We could sing her favourite songs,
and toast her,
and tell stories about her…"

"And… and…"

And they all became excited about the party
and began to make plans.

It was as if Methuselah was right there,
conducting them with her tack hammer.
They chose her favourite hymns,
and practised with instruments and song.
They decorated the barn, planned party food,
picked wild flowers and arranged them in jam jars.
They borrowed mugs, plates, and glasses.
Finally they were ready
and posted an invitation in the Home.

Everyone is invited to
a WAKE
to celebrate the life of Methuselah
at
the Grannies Clubhouse
at 3 o'clock, on Sunday afternoon

A bus will leave from the front door at 2:45 PM
B.Y.O.P. (bring your own pillow)

Sunday afternoon was especially sunny
and the Grannies waited eagerly
at the clubhouse for their guests.

As everyone arrived
they were greeted and shown to a bench
(except those who came in wheelchairs).

They made a big circle,
and "the Mob" began the ceremony
by playing softly on their instruments.

Then they started singing,
"When we gather at the river,
the beautiful river of God."

But after the first verse
they got carried away (as usual)
and soon everyone was singing and clapping,
and the little barn rocked.

After the music,
everyone took turns to remember Methuselah,
sharing stories and paying tribute
to a life well lived.
There were funny bits, and sad bits,
remarkable accomplishments,
and homely everyday happenings.

Then it was time for tea,
and a toast to *Methuselah!*

They all jumped up and gathered around the table,
wolfing down enormous quantities of
sandwiches and cakes and tea.
(Wakes make you very hungry.)

When the bus came to pick them up,
it was almost as if Methuselah was there…
smiling at them
and waving goodbye.

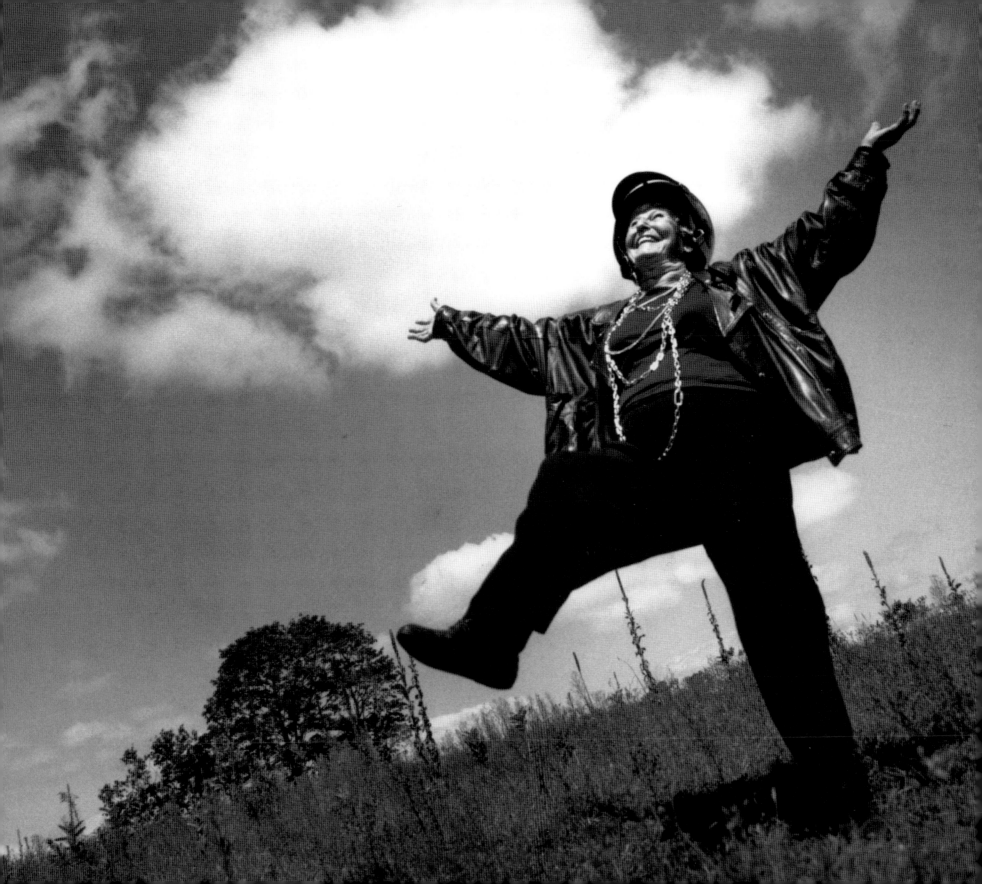

THE NEW LEADER

The day after the Wake,
the Grannies gathered around the table
at their clubhouse to choose a new leader.

Over a cup of tea, they pondered:
"Which one of us shall it be?"

Just then, Mary, the farmer's wife, hurried in.
"I only have a minute," she said,
"but Methuselah wanted me to give you this."

And she handed over an envelope
with *The Grannies* written on it.

"From Methuselah?" they all cried out in amazement.

Big Bertha was nearest,
so she opened it and read aloud.

Dear Gang:

I want to tell you how much joy and challenge
I have had in the past months.
I have laughed and laughed,
and felt like a young girl again on my machine.

You have become my close and good friends,
but when you read this,
I will no longer be with you.

As you know, I always like to be prepared,
so I have enrolled you in Computer Studies
for the fall semester at the High School.
Word Processing is a popular course
that gets filled quickly, so I had to act fast.

Mary has the laptop computer
I purchased for the clubhouse.
On it, you will be able to learn word processing
and write down your remarkable memories.

Above all, during the winter months,
you can meet in the Party Room at the Home
and read your life experiences to one another.

Remember, group energy is a weapon.
Although each of us is just a frail old woman,
together we are a force.

As for your new leader,
I have selected
"She Who Will Follow Me."

It was very difficult to decide,
so I wrote down all your names and picked one,
and the new leader is
Stay-at-Home Mabel!

Because names are important,
she will now be known as "Able Mabel,"
for she no longer Stays at Home.

I hand my tack hammer over to her
and know she will be a fine leader.
Let her commence her term of office now!

Methuselah

At this point, Big Bertha passed the letter around,
picked up the tack hammer,
and tapped it lightly on the shoulder
of Stay-at-Home Mabel,
saying solemnly:
"I now pronounce you
Able Mabel, our Leader."

And Able Mabel rose with stately grace,
and sat down in the empty chair
at the head of the table.

Mary, the farmer's wife,
came back with her baby in the stroller.
Tea time!

And they all drank a toast to Able Mabel,
and a special one to wise Methuselah,
who was prepared.

But privately, each Grannie queried:
"Computers?
I thought they were for the young,
the technology generation…
but…
I *did* learn to ride a motorcycle.
Why not give computers a try?"

And so, on the first day of term,
another surprised teacher met Able Mabel and her bikers
when they walked in with helmets tucked under their arms
after a graceful swoop up to the school.

"Computers! Here we come!" they exclaimed.
And they *all* learned.
(Because once you set your mind to do something,
it *can* become a reality).

THE COMPUTER WORLD

Reluctantly, the ladies prepared their steeds for winter,
covering them with flannelette blankets
and fondly patting them goodbye.

"What rides we have had,"
they murmured to themselves.
"Every tree glowed and blazed like a candle in the sun!"
"I felt like I was riding on a beam of golden light,
and it made me think of Methuselah."

The door opened and in came Mary
with the baby pushing the stroller.
He ran around and hugged every Grannie.

"Come for tea at the farmhouse
as soon as you are ready,"
said Mary.

Around the kitchen table,
the Grannies talked about computers.

"Technology is a miracle."

"The screen is like a mirror,
but instead of reflecting the world,
you can walk right into it, into the land of memory."

"You just have to learn the passwords, "
and a slight *groan* travelled around the table.

"Our instructor led us from
ON to SHUT DOWN with SLEEP in the middle.
What a patient man he was!"

"We even had daily tests!"

"We went through all the chapters in the book, page by page."
"We kept up with the class and passed Word Processing One!"

"Wouldn't Methuselah be proud of us!"

And they all agreed.

Rosa: "Even though we know about air waves and breathe them in daily,
the universe is still *incomprehensible*."

Double Trouble: "We twins always communicate without words,
but computers lift everything into orbit!"

Mary: "If technology gets too much,
we should just pull the plug and get back to start!"

The Witch: "Do you think the world would come to a stop
without power and buttons to push?"

Big Bertha: "Of course not,
for *we* know what it was like B.E. (before electricity).
We have all lived with oil lamps and horse power!"

And the Grannies suddenly became awestruck
with the same thought at the same moment.

"*We are fossils!*" they exclaimed.
"We belong to the age of the dinosaur."

And another groan travelled around the table.

Able Mabel rose and said in a firm voice:
"No, we are *not* dinosaurs!
We are Word Processing Technicians!
We have kept up with the world…
but…
Why don't we make a record of how people managed to live
without electricity?
We could describe a time when the only tools we had
were our two hands, common sense, and a lot of luck.
To be self- reliant,
and not at the beck and call of a switch or button,
is a wonderful feeling!"

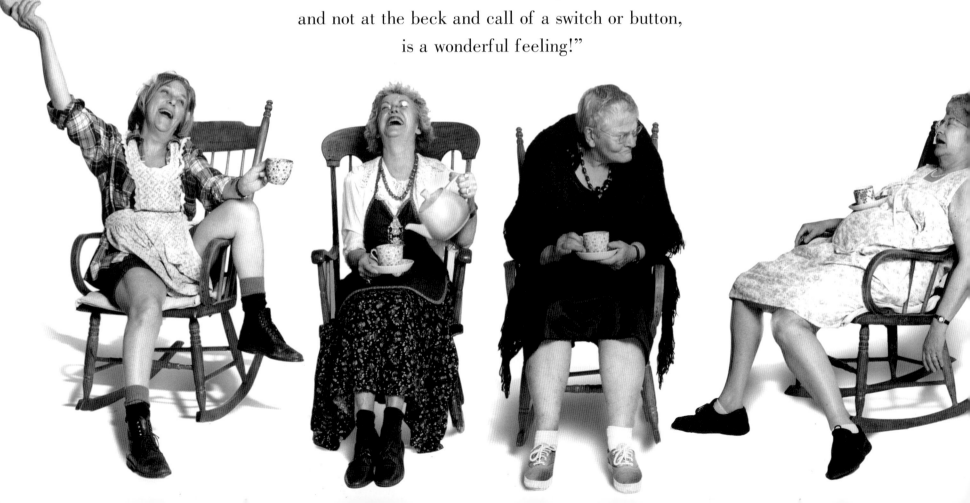

The Grannies sat quietly for a moment,
recollecting scenes from their childhood.

The same IDEA occurred to them at the same time:
"Let's write a book together!"

During the pause, Mary suggested:
"Why don't you begin with your own stories?
It's always a good idea to start where you are at."

"Let's try!" said Able Mabel.

And they all agreed.

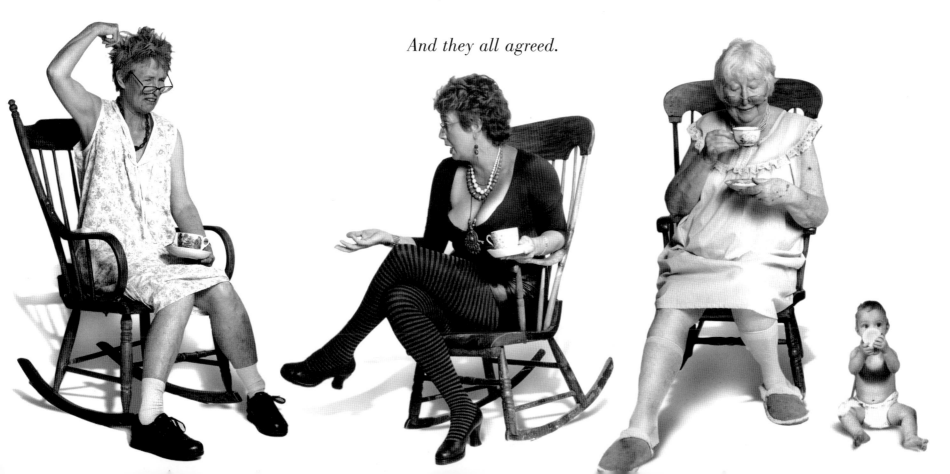

GRANNIES B.E.
(Before Electricity)

Now that winter had descended in earnest,
the Grannies liked to sit in the hot tub at the Home,
sharing memories about life B.E. (before electricity).

Able Mabel: "Each day seemed much longer."

Rosa: "It was because we had to work so hard
just to keep alive."

The Witch: "Without switches to pull,
and buttons to press,
we had to do everything ourselves,
...or do without."

And they all agreed.

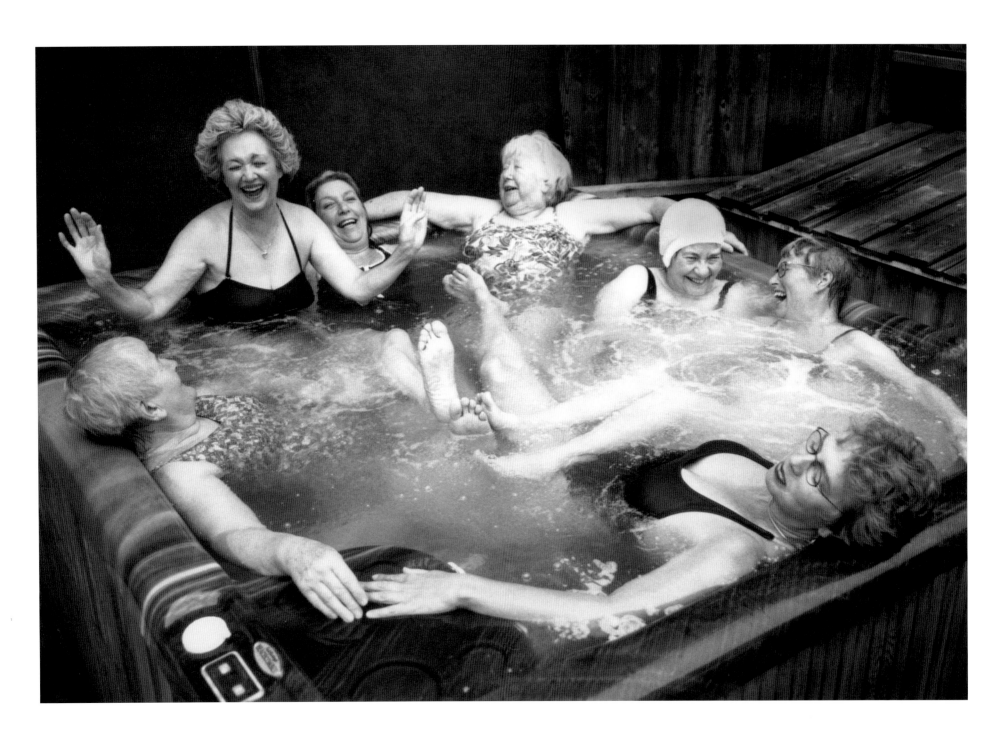

Big Bertha: "But we had no time to complain when we were young,
we just pitched in.
We *had* to help."

The Twins: "It wasn't all work, we had fun too!
Remember playing with mud pies,
and making dolls out of twigs,
church socials, and square dances,
and a time when weddings were weddings?"

The Witch: "I loved to read
and learned my letters in the graveyard,
spelling out names on tombstones."

Rosa: "In our family we liked to recite around the table
in the flickering light of the coal-oil lamp.
Remember the story of 'Simon Legree?'
It gave me goose bumps!
Sometimes we told ghost stories,
and I was afraid to go to bed."

Big Bertha: "Now, everyone can relax on the couch
and enjoy stories and movies on their TV screen,
and change the channels with a flick of their remote control.
They don't even have to move."

Able Mabel: "But what has become of the families
who used to recite, and tell stories to amuse themselves?
Are we becoming robots?
Has electricity taken over our lives?"

And they were silent for a moment
watching the warm water bubbling around them.

Then Double Trouble replied in unison:
"Not really… but we are certainly
more comfortable, and rested, and clean."

The Witch: "And we have libraries, and talking tapes,

and time to read and listen to music,

and to visit and chat in a hot tub.

Television brings the world to us!

And computers offer us even more incredible possibilities!

There is *so much* to learn."

Big Bertha: "Electricity has provided us with more than just power.

It gives us choices."

Rosa: "Years ago, Grannies couldn't live in a lovely Home.

They had to put up with their children or relatives,

and help with the work, always feeling they were

one more mouth to feed.

They would peel potatoes, knit socks, and mend,

kill chickens and pluck them,

and keep the fires going…

until it was time to 'fail'

and be buried next to their husbands."

And the Grannies looked at one another and twinkled:
"Instead, we ride motorbikes,
and have a clubhouse,
give concerts,
and write memoirs on our computer.
We have time to visit,
and drink tea,
and consider our own wishes."

"Hurrah for electricity!"

And they sank back into the lovely water...

as they all agreed.

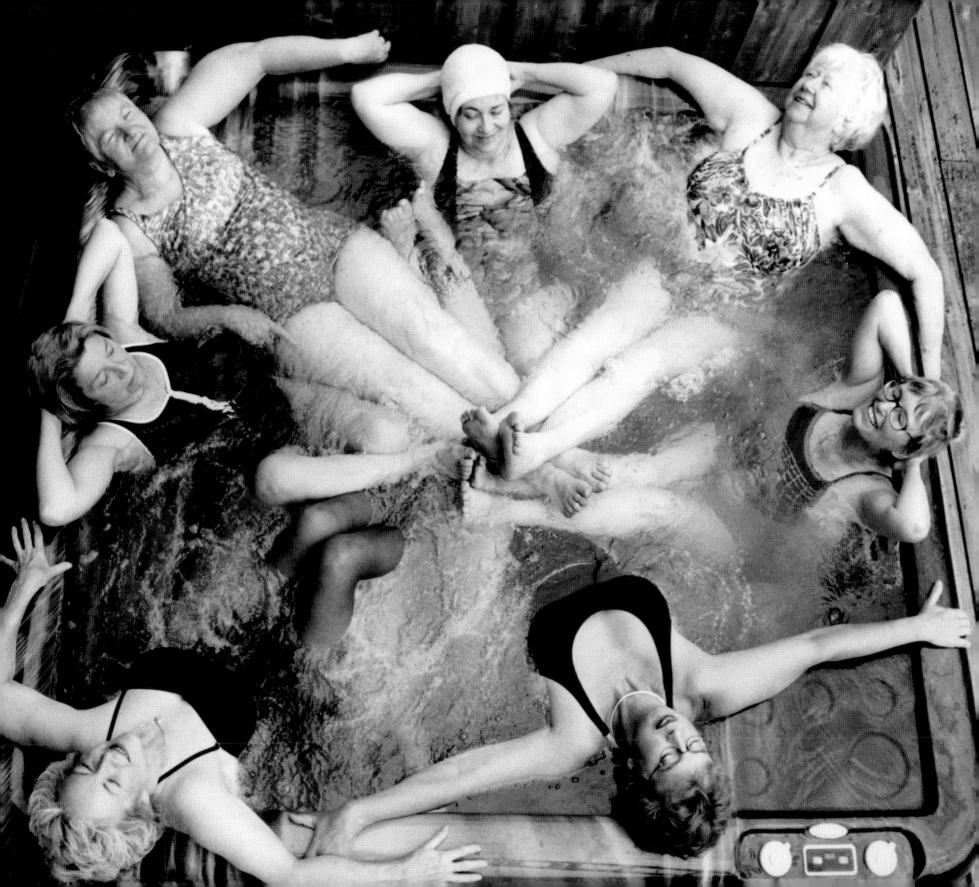

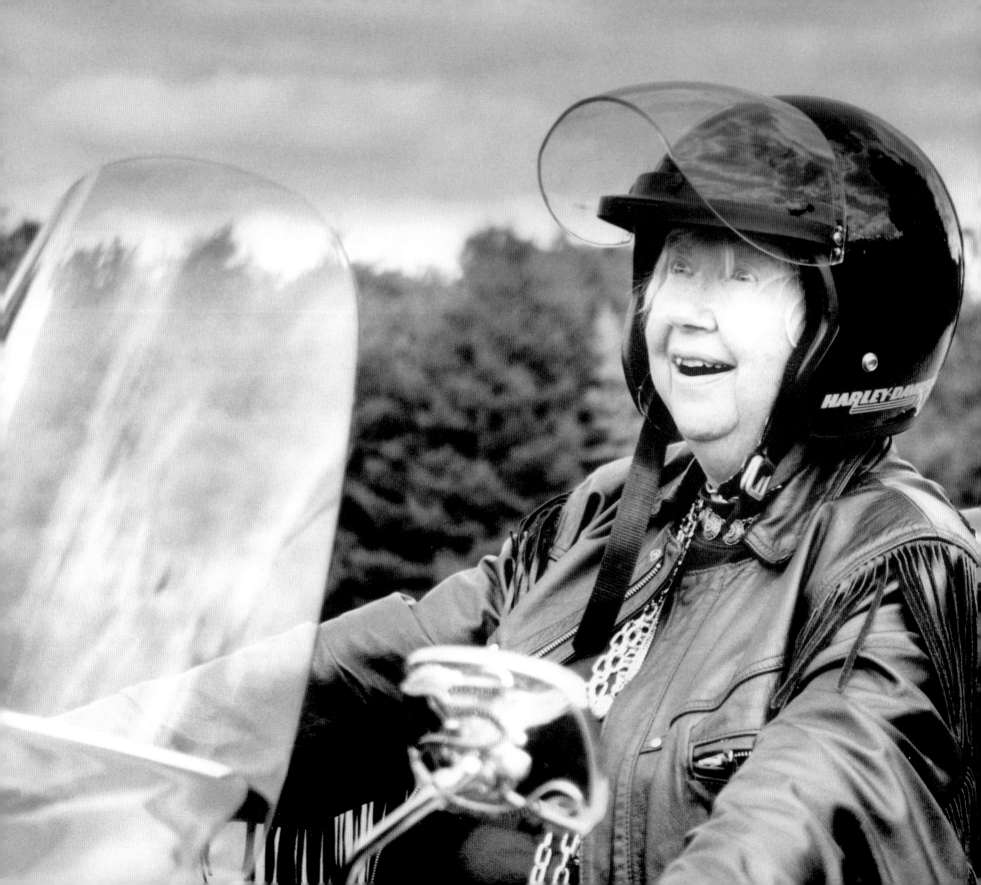

8

BIG BERTHA'S STORY

The Grannies were gathered in the Party Room at the Home.
They had followed Methuselah's suggestion
that they write down their life stories
and read them to one another.
While one of them used the laptop computer,
the other Grannies scribbled in their notebooks,
making little humming noises to themselves as they wrote.

Their minds were lively with yesterdays
and the effort of turning memories into words.
Their discussions went like this:
"Life was so different when we were young."
"What enormous changes have come about."
"What is the world coming to?"
"Where has the time gone?"
And concluded with:
"But we must keep up or become extinct before our time!"

And they all agreed.

Everyone turned expectantly towards Big Bertha,
the first Storyteller,
sitting in the place of honour at the head of the table.

Able Mabel opened the reading
with a *leaderly* expression on her face,
and addressed the Reader's Chair:
"Are you ready to tell your story?
All we really know about you
is that you used to ride a mule over the mountains."

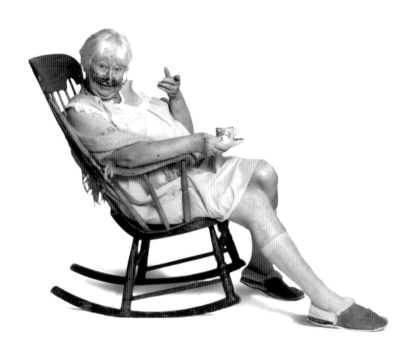

"Well," said Big Bertha in a story-telling voice, "That is true."
"It happened when I was in the army.
I joined up during World War Two
and was posted overseas.
I was a driver, and saw it all.
I even walked with school children
on a narrow path beside a peaceful stream.
If we had stepped off the path,
foot mines would have exploded!

Towards the end of the war,
my jeep blew up and I got left behind in Italy.
I was taken in and cared for by a family.
When I recovered, I rode their mule up into the mountains
and helped gather firewood.

When the war ended,
I came home and married one of the guys in my unit.
I saw the world, but it was a hard way to see it.
It made me appreciate home and peace.
I brought up my children praying
they would *never* have the memories I have.

They are good children and studied hard.
Now they have gone into the world
to make their own lives.

My husband died, and I came here.

I never want to be a burden to my children.
I enjoy their visits, send them birthday presents,
and spend time at Christmas with them.
They were so astounded when I first roared up
on my shiny red motorcycle,
they called me "Whatta Grannie!"

Each day is precious,
and I want to spend it to the full
and have no regrets,
just like Methuselah.

Writing this has been a challenge.
How can you put a whole lifetime into a few words?
But I am glad I have tried.
My family wants to know more
so I think I will keep right on writing.

Now you know a bit more about my mule.
In spite of the circumstances
I loved that moment in my life.
The mountains were beautiful, and the people kind."

Big Bertha laid down her paper with a faraway look on her face.

After a short pause, the Grannies began to clap
and they all rose to their feet to congratulate her.

Able Mabel briskly took the meeting in hand,
and asked:
"Who is next week's Storyteller?"

"We are," replied Double Trouble.

"I can't wait," said Big Bertha.
"And now I need a cup of tea."

She wiped her hand over her brow.
"Whew! That was a tough ride!
Riding mules was a lot easier…
But I did it!"

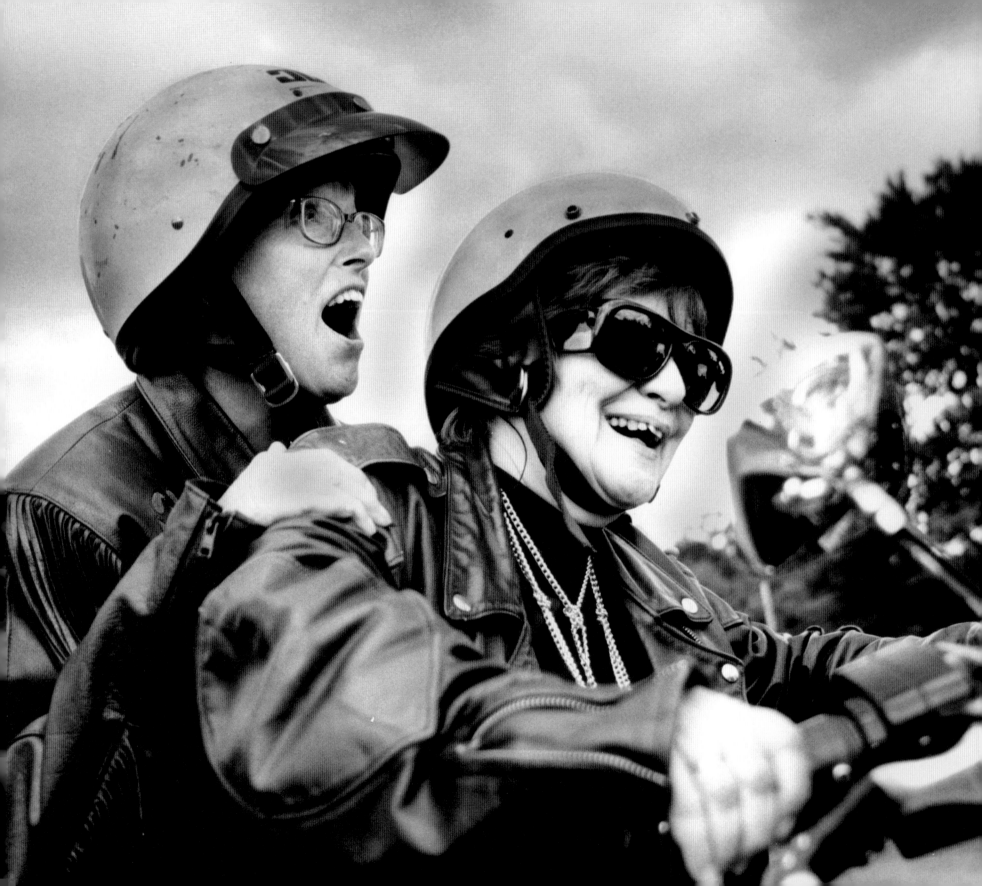

9

DOUBLE TROUBLE'S STORY

A week later,
the weather being extremely cold and blustery,
the Grannies were happy to be having tea
in the cosy Party Room.

"Story time!" they said.
"We've been looking forward to it all week."

The Twins added another chair
to the place of honour at the head of the table
as they said in unison:
"We don't really know where to begin."
Then they looked at each other with a grin and said:
"We will take turns talking…"
"a sentence each."

"Our mother entered us in competitions for beautiful babies..."

"and we always won."

"We made commercials,"

"and advertised toothpaste,"

"and laundry soap."

"We even modelled for Eaton's Catalogue."

"During World War Two, we were famous..."

"as The Mud Wrestling Twins."

"We raised money for the war effort,"

"and cheered people up"

"by flailing around in a tub full of mud!"

"Being identical, it's as if we're each other."

"Which of course presents a problem with husbands."

"So we married identical twins."

"We thought that would make it easier."

"But when we both had identical twin babies..."

"it got really complicated."

"Of course it's easy to know which of us is which,"

"because when we joined the circus,"

"we got the Snake Lady to tattoo us..."

"with a different flower."

"Mine is an Iris," said Iris.

"And mine is a Poppy," said Poppy.

"Our husbands were happy to do the same."

"George chose a dragon."

"And Nick a devil."

"We even had babies on the same day."

"Four little boys looking like peas in a pod."

"In order to identify them at the hospital,"

"each had a little bracelet on his wrist."

"But when we got home,"

"we decided to tattoo them as well,"

"on their big toe."

"Otherwise it would have been impossible."

"John and Joe got numbers 1 and 2."

"Michael and Mark, 3 and 4,"

"in order of birth."

"Of course they got into a lot of mischief at school,"

"and did each other's homework,"

"and fooled the teachers, and even us."

"We never knew who was who,"

"but we got used to it."

"Strangely enough when it came to careers..."

"they all went in different directions."

"John is a TV producer, Joe a farmer."

"Michael is an architect, and Mark a teacher."

"We suggested they marry quadruplets,"

"and produce triplets on the same day."

"But they didn't."

"They have fine families of their own,"

"and live in different towns."

"Both our husbands died on the same night,"

"of heart attacks."

"So we decided to live together."

"But then we got lonely,"

"and thought we would have more fun in a Home."

"With other Grannies."

"Looking for things to do..."

"that are fun for Grannies."

"And here we are."

Then together they said:
"Now we will do our soap commercial for you."
And the old ladies who looked like one
leapt to their feet and began to dance,
waving their arms and singing,
"Rub a dub, Rub a dub,
Three men in a tub."

They were uproariously funny and only stopped
when Able Mabel said the magic words,
"Time for tea!"

During tea, the Grannies reminisced
about the early days of advertising.
They quoted famous commercials
repeated day after day on the radio
and laughed over how they had believed
every word.

"So it was *you* who sold us on the cleaning powers
of Sunlight Soap,"
marvelled the Grannies.

"Imagine that! Isn't it a small world!"

And Iris and Poppy just smiled,
identical smiles,
as they all agreed.

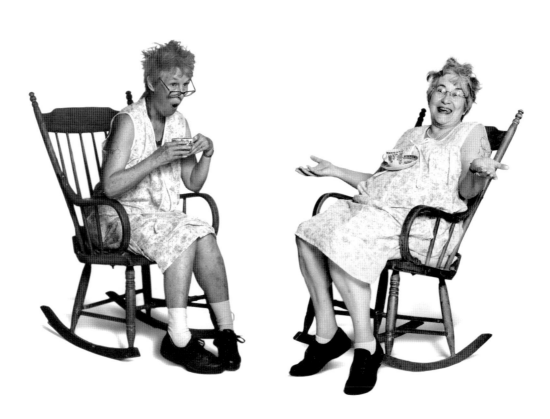

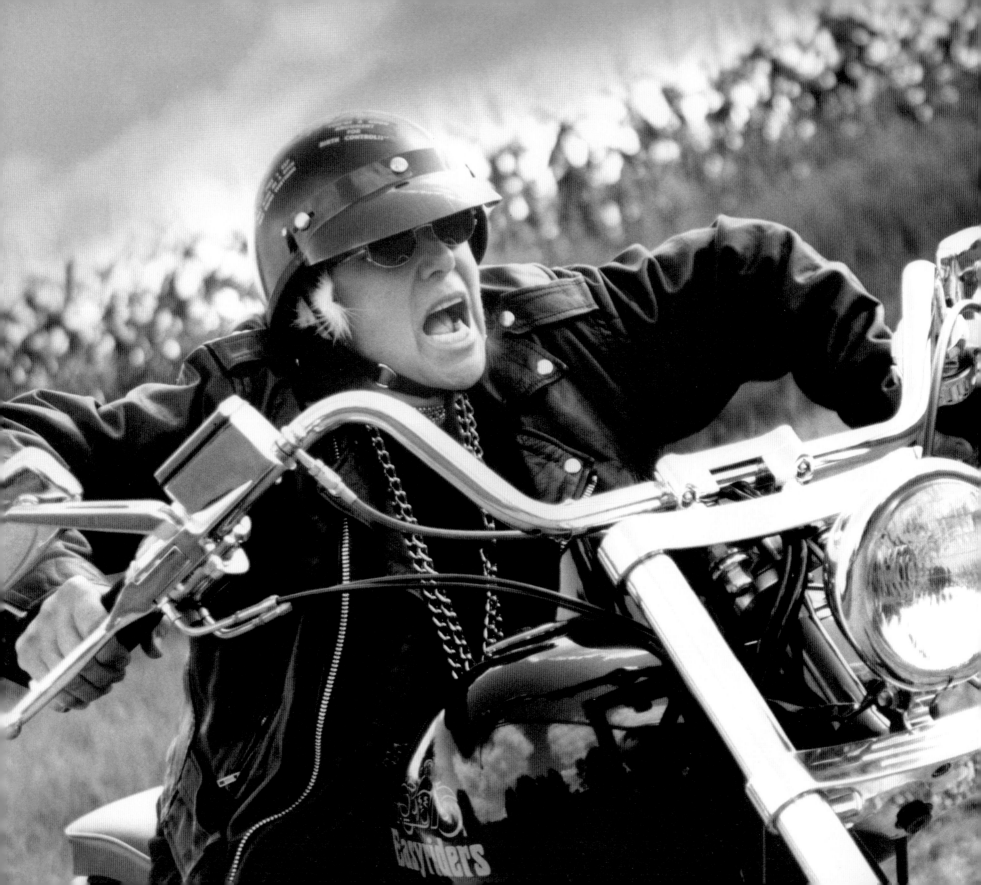

ROSA'S STORY

Christmas at the Home was finally over,
the carollers departed, the presents opened,
and the tinsel put away for another year.

The Grannies gathered once again in the Party Room
in their new slippers and cardigans,
smelling of Lily of the Valley and Lavender.

This year, something new had been added —
each Grannie had her very own laptop computer,
a present from her family.

As they sipped their tea,
Able Mabel turned to Rosa and said:
"You once mentioned that you raised 13 children
on a chicken ranch.
Tell us about it."

Rosa gave a little cackle, not unlike a chicken,
and began:
"It was so long ago it seems like a dream.
Each day flew by, and the weeks and the years.
You could say I was addicted to babies.
As soon as they could toddle,
my arms would feel empty,
and I would long for just *one* more.
Diapers were another thing.
Pampers were not invented,
but I was so proud of my snowy white diapers,
washed and hung on the line and folded just so.

Home was like a rock, the centre of the universe.
Each day was a challenge, full of adventure,
and love, and noise, and doings.
Everyone felt I should moan and groan
about the work, the work, the endless work,
but it wasn't like that.
Of course there was a lot to do, but we did it together.
We had a good life.

Life was so different then!
We worked hard but we had fun as well.
We played Euchre and went to dances,
had picnics and swam in the pond.
We tobogganed in the winter,
and cut down our own Christmas tree.
Around the table, after supper,
we told stories, or just talked and laughed and shared.

In those days,
we could not even begin to *imagine* TV,
let alone the computer!
But we went to the movies,
and listened to the radio.

There was hardly any crime,
well… maybe just a little."

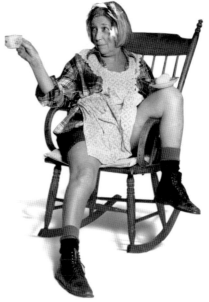

As you know, chickens were our big source of income.
I loved the fluffy yellow chicks.
We would prepare the brooder house early in the spring.
First we washed down the walls with lye,
then we brought in the cast iron stove,
and put its chimney up through the roof.
We clamped the big tin hood around it
so the chicks could shelter under its warmth.
We covered the floor with bright yellow straw,
put food in the troughs, and filled the water fountains.
At last we were ready to empty the boxes of chicks
into their new home.
I loved listening to the little things
chirping and pecking and sipping.
It was like music.

In the fall, just when the chickens were ready
to lay eggs or go to market,
thieves would come in the night.
They would park their car on the road,
and sneak into the field carrying feed bags.
They would grab the sleeping pullets by the legs
and pop them into the bags before they could even squawk.
In the morning the chicken house would be empty,
and the farmer's heart broken.

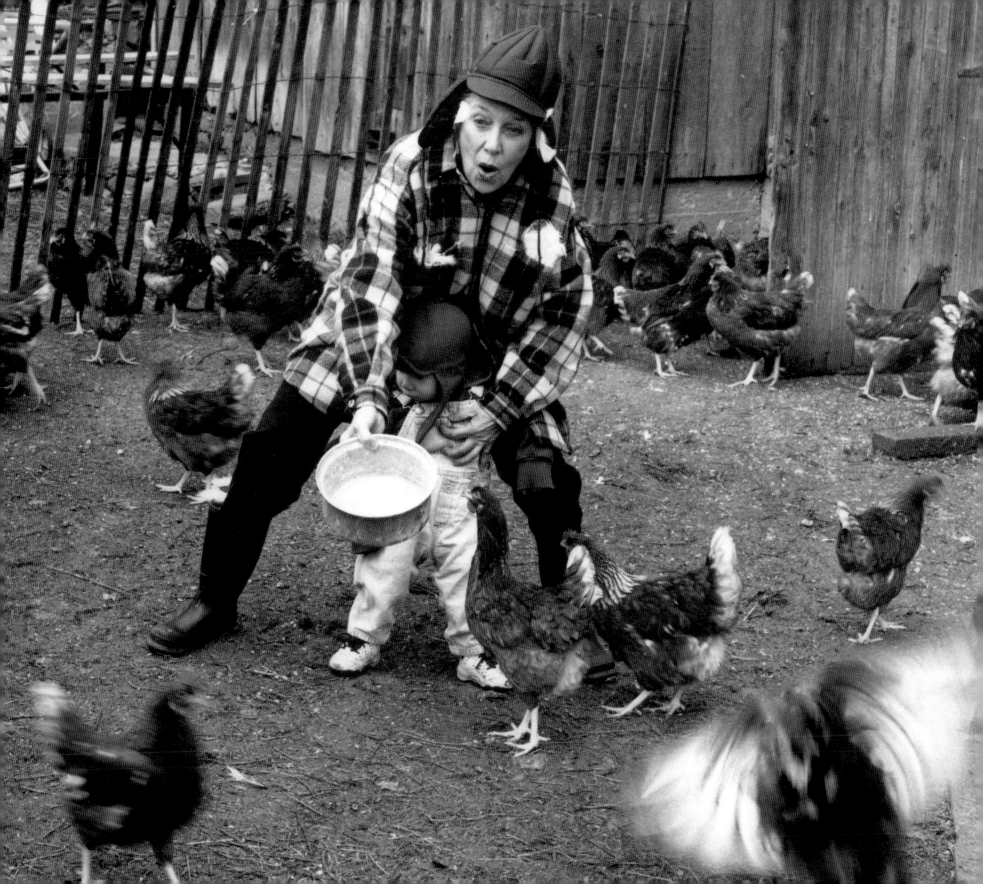

We didn't dare sleep at night in case
the thieves came to steal *our* chickens.
We kept the doors and windows open,
and listened for the fence to creak.
One night it did!
We all rushed out into the darkness,
(for they never came when the moon was full).
The whole family ran out, some towards the chicken house in the field,
others to the road to look for the car,
and we found it!
My husband shot out its tires with his World War One service revolver,
and pulled the wires from the carburetor.
I called the police.
They came and we waited and waited.
Finally the owners of the car turned up.
They had run out of gas, walked to the corner,
and got caught up in a poker game.
They were quite astonished to find their tires flat.
At first we were embarrassed, and then we laughed and laughed.

Eventually, the thieves were caught by a farmer's wife
who recognized her pet chicken with a crossed beak
hanging up in a butcher's shop.

Life was never quiet or dull on the farm,
but it flashed by at such a speed.
It was just like roaring through the countryside on a motorbike.

One by one the children departed, and then my husband died.
The house became as empty as the pullet house
after the thieves had come,
so I sold it and moved here.

And here I am, free as a bird,
a *Biker Grannie!*
What more could I ask?"

The Grannies clapped loudly
as they all agreed.

Able Mabel looked at Rosa's hands,
and thought about all the work they had done.
"What a useful life you have led," she commented,
"and how many grandchildren and great grandchildren do you have?"
Rosa replied, "Forty-nine, and one more on the way.
Almost enough to fill a chicken house."

And everyone laughed.

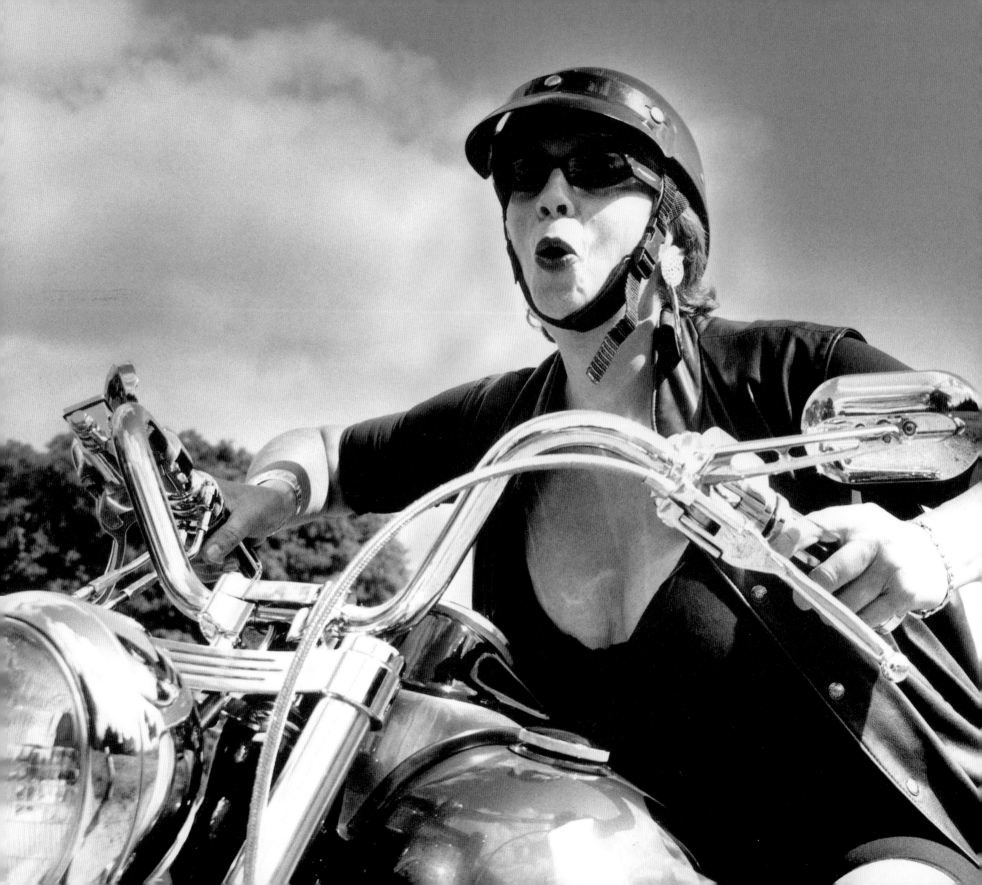

11

GRETA'S STORY

A week later,
the Grannies were back in the Party Room
looking at Greta with anticipation,
eager to hear her story.

They had wondered for a long time
why she dyed her hair
such a brilliant hue of henna.
Not that it didn't suit her, because it did.

"Perhaps you'd better drink some tea first,"
Greta said,
"to prepare yourselves for my tale."

When they had all settled down,
she picked up her story and began to read
in a careful sort of voice.

"I was born in the city.
At that time it had one solitary bar,
and the streets and street cars were emptied by 10 o'clock.
It was a dreary place and I was bored,
so I ran away with a circus."

Suddenly Greta threw down her paper
and looked at the Grannies
with a twinkle of mischief in her eyes.

"I was married five times, " she confessed.
"The first one was my fault, I was too young,
but the rest just seemed to happen.
I buried a few, and some left me,
but there was one that I truly loved...
and I lost him.

I liked things to be quick and easy.
I never had any children,
but I inherited instant ones
that came with some of my husbands.
Now I have instant grandchildren.
Most of the time I like them and they like me.

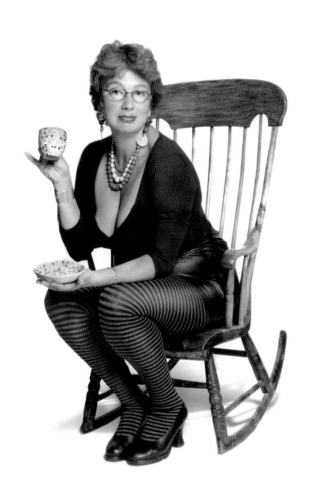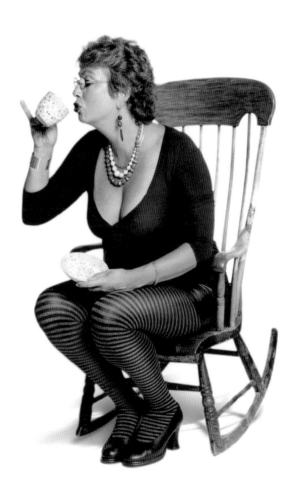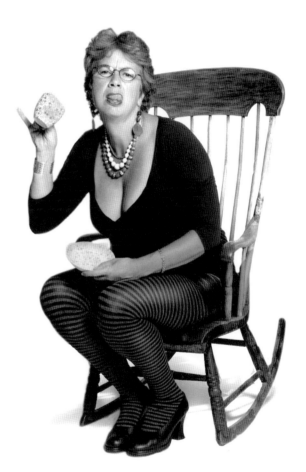

I always wanted to have a good time.

I loved to dress up, and go to dances, and meet new people.

Life was a big party.

A place to laugh a lot.

And I thought I would always be young.

Then one day I woke up all alone

and realized that I was old.

Life was over, done, washed up, I thought...

So I drank a lot, and dieted, and took Valium.

I did it all, but it still wasn't enough.

Finally I found a therapist, and joined the A.A.

Slowly I began to understand what life is really about.

I volunteered at a hospice

and found I could actually help!

I am a cheery sort of person,

and perhaps this is my special gift.

Everyone has a special gift.

I just had to learn how to use mine.

I loved my work, but then...
I became too sad when my patients died,
so I had to take some time out...and came here.
I still do volunteer work,
but only when I am strong and happy.
I visit people in hospitals who are all alone,
and I am their only visitor.

Happiness comes from within,
and my work has given me much joy,
for I have found patience and acceptance,
compassion and kindness.

But when I ride my motorbike, I leave everything behind.
I feel I am flying, weightless, and free.
Free from selfishness and vanity.
Free from old age.

And I still like to dance and enjoy myself,
and be a *Biker Grannie!*"

Suddenly she threw up her hands, leapt to her feet,
and burst into the old wartime song,
"I have a lovely bunch of coconuts."

Everyone stood up and joined in,
clapping their hands and shouting and singing
through a few rousing choruses.

Greta waved her arms, wiggled her hips,
and exclaimed:
"Let's do the Conga!"

The Grannies hitched themselves on behind
and jiggled about the room chanting:
"One, Two, Three, Oomph! One, Two, Three, Oomph!"

After a few rounds, they collapsed onto their chairs
laughing helplessly
and had to have another cup of tea.

"Life's too short to worry about tomorrow,"
panted Greta.
"Live for the day, I always say."

And they all agreed,
and went back to their rooms for a rest.

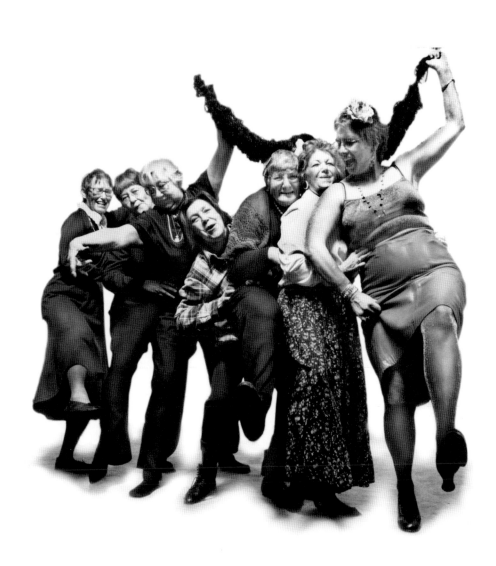

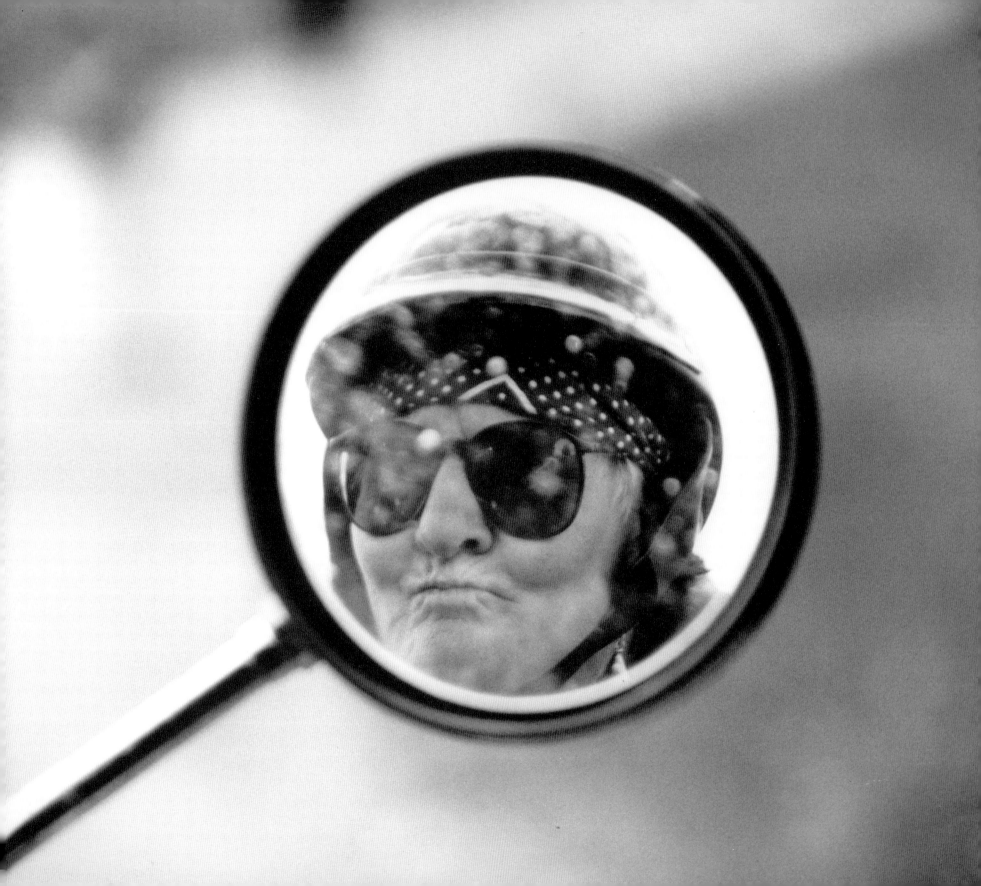

THE WITCH'S STORY

"Spring is just around the corner,"
said Able Mabel.
"Soon we will be able to dust off our motorbikes
and take to the roads.
I can hardly wait."

And they all agreed.

As usual, the Grannies
were gathered in the Party Room
talking and working on their memoirs
and making plans over a cup of tea.

"Whose turn is it to tell her story?"
queried Able Mabel.
"Mine," said The Witch as she moved to
the Storyteller's chair and
began her tale in a sing-songy sort of way.

"I, too, was born on a farm
and went to a one-room school house on a pony.
We were a large family,
and one day we heard on the radio
that we were at war with Germany.
My oldest brother joined the army and was sent overseas,
and we worried about him.
The war seemed to go on forever.
We had gas rationing and sugar rationing.
We grew our own food,
and helped our neighbours.
My war work on Saturdays was
chopping cabbages in a dehydration factory.
It was so dull, I decided to go to university
when the war was over.
And I did.

I have always been a curious person,
and never know where I am going
until I have been there.

After university I went to Europe on a dollar a day,
and found myself in Paris studying art.

My grandmother gave me some money
and I bought 'The Witch,'
a bicycle with a motor on the front wheel.
It was my key to freedom.
I could go 17 mph and 365 miles a gallon.

I took off down the Loire valley,
slowly putt-putting from chateau to chateau,
breathing in the golden fields of wheat
sprinkled with red poppies.

I stopped at the villages to explore ancient stone churches
and dream about the people who had passed by so long ago.
I kept right on going until the mountains got too high,
and I discovered I was crossing the French Alps.

It was quite an experience to be all by myself.
Wherever I went I made sketches
and wrote letters home about my adventures.

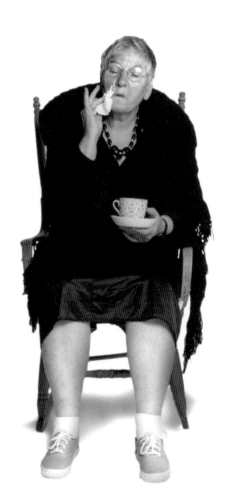

I met my husband at art school in Paris,
brought him home to the farm,
and we had lots of babies.
Raising them was a challenge,
for each one was like a new country
to be discovered and relished.
Now they are grown and flown,
and I am back on a bike with a motor,
exploring the world around me.

I still like to sketch and write stories,
play with friends, and take risks.
The experience of living gets richer and richer.
The trick is to realize it, and the problem is
we have so little time."

The Witch stopped her story abruptly.
The Grannies looked around at one another
and gave a little sigh of understanding.
They *had* to have another cup of tea
to cheer themselves up.

They began chatting about their own travels,
and the possibility of an outing.
"Let's hire a Grannie bus and see if Niagara Falls is still there,"
suggested the Witch.
And they all agreed.

Able Mabel was particularly excited for she had never been.
She had Stayed Home!

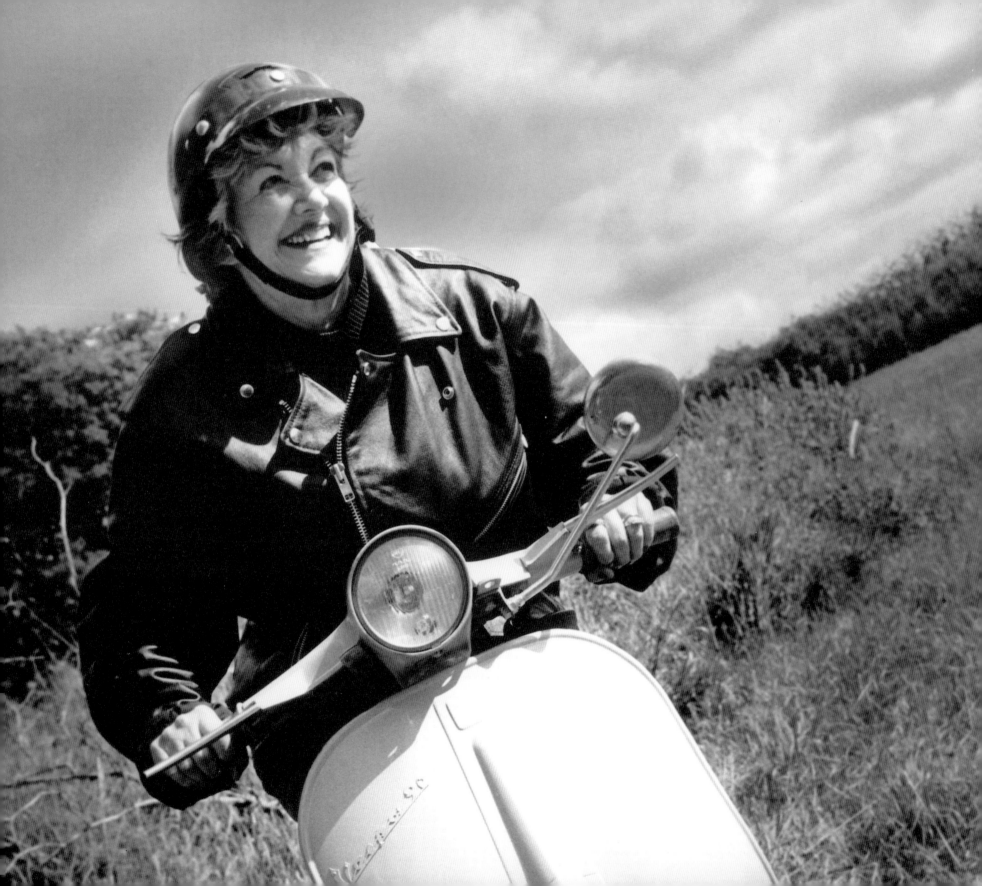

ABLE MABEL'S STORY

A week later, the Grannies gathered again
in the Party Room to hear Able Mabel's story.

She looked around the table at all her friends
and said quietly:
"Now it is my turn to share my story.
I have been thinking about the purpose of my life
for some time.
You have given me so much,
and I realize how each of us is just a cog
and how everything is linked and interacts.
If we do our job well,
the machinery runs smoothly,
but anger and jealousy, hate and injustice
mess things up.

It's up to each of us to do our bit
to make things better around us
and I tried, but quite often I failed."

"Being with you and taking my turn as your Leader
has been wonderful.
I feel so fortunate to share in your lives and experiences
because I have had so few.

When I grew up, one daughter was expected to care
for the parents in their old age.
I was chosen for the position.

I tried to escape, and married a soldier
just as he was going overseas.
Sadly, he was killed before our son was born,
and I became Stay-at-Home Mabel.
My parents lived to a ripe old age
and I looked after them to the end.

The joy of my life was my son.
He was the greatest gift of all,
and brought life and laughter,
and all his friends home to the house.

Then my parents died, and my son grew up.
He found a lovely wife and I have beautiful grandchildren.
But I became lonely and sad.

I put myself into this Home,
because I had resented looking after my parents
and didn't want to put my son through it.

What a surprise it has been to discover
that there *is* life after sixty,
and your heart never grows old,
and dreams can become a reality.

When poor old Stay-at-Home Mabel
turned into your Leader, Able Mabel,
I felt like a butterfly emerging from a chrysalis.

Life is not a competition.
It's just feeling good about whatever comes your way,
and it has been good.
Thank you."

Able Mabel stopped reading and looked around the table.
She was astonished to see a few tears,
but she knew they were not sad tears but glad tears.
So she said,
"Let's have another cup of tea!"
And they did.

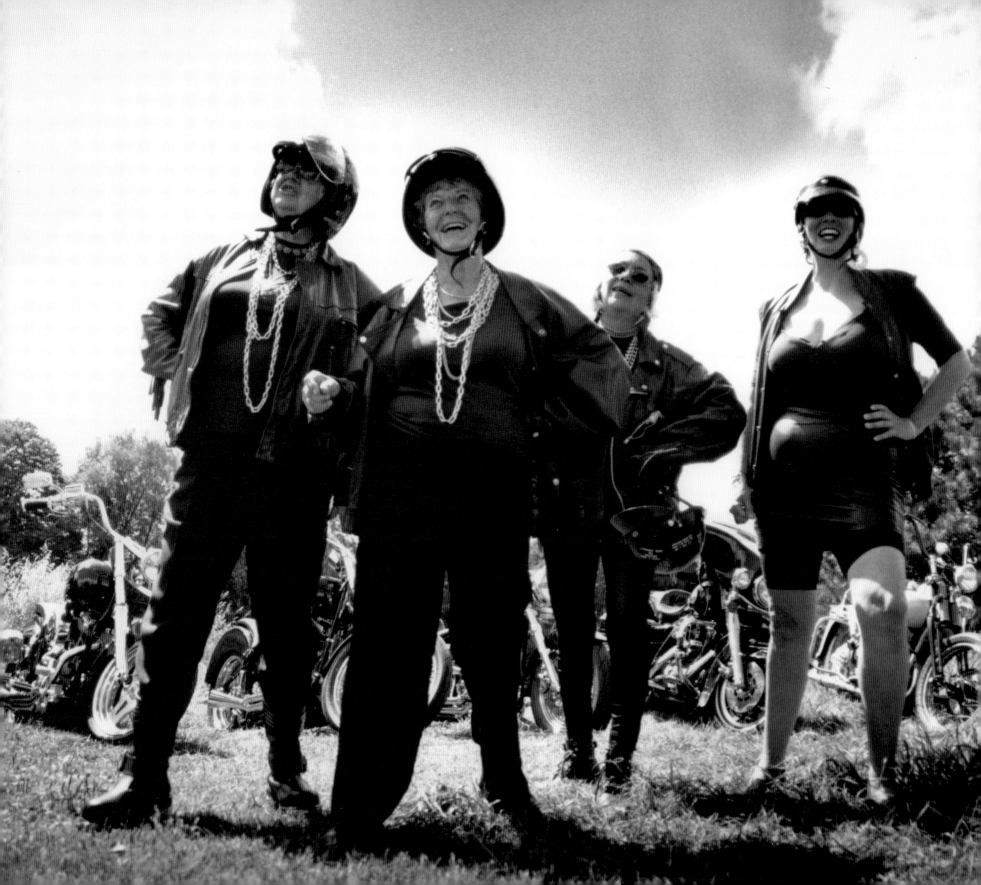

14

METHUSELAH'S STORY

Spring had arrived and everything was stirring
except the Grannies, who had all read their stories,
and now sat in the Party Room with their tea,
pondering what to do next.

Suddenly, Mary, the Farmer's wife,
poked her head through the door and
came in with her baby,
who ran around hugging every Grannie.

Mary: "I know you have finished your stories at last,
and I have a surprise for you.
I promised Methuselah that on this day
she would congratulate you with roses,
and here they are!"

The door opened again
and big bunches of red roses
were delivered to the Grannies,
with a note in Methuselah's handwriting.

"I always like to be prepared,
and want to be with you on this great occasion."

Somewhat mystified, the Grannies turned to Mary,
and she smiled and pulled a large envelope out of her diaper bag.

Big Bertha opened it, smoothed out the papers
and began to read aloud:

Dear Gang:
By now you will have put to use
your new skills on the Word Processor,
and shared your life experiences.
I am sorry I didn't have time to learn too,
so I will write this by hand.
Because I am a part of the Gang
and always like to be prepared,
I have written my story for you,
and here it is.

Big Bertha handed a notebook to Able Mabel.
Able Mabel put on her glasses, opened the notebook,
cleared her throat, and began to read.

My parents lived in Vienna
and belonged to a banking family.
All my relatives lived in the same house,
each family in an enormous apartment
which took up an entire floor.
I was brought up by servants
and saw my parents once a day,
for they were important people and had many duties.

One summer my mother took me to Italy.
She always went to Italy for her holidays,
but this time she took a great many jewels
to put in the hotel vault
because she too liked to be prepared.
She was nervous about the political situation
for my father was a Jew.

One morning, my mother received a telegram with one word,
"FLEE!"

My father had arranged with her what to do in case of an emergency.
We rushed to the train station.
First we went to Switzerland, and took our money from the bank.
Then we got on an overcrowded train and boat
and travelled to England.
My father was already there, waiting for us.
Together we crossed the Atlantic on the Queen Mary,
and came as refugees to North America.

We spent the war wishing that our families
had been prepared as well.

I determined to use my life to help others,
and became a Social Worker.

One day I met a wonderful man
and was not quite prepared to be so happy.
We married and had children.
Time passed too quickly
until one day I was alone.

Where could I use my skills?

So I came to the Home
to find new friends and a new purpose for my life,
even though I was old.

I was not prepared to have such a good time!
Without your energy, my friends,
I would never have learned to ride a motorbike,
or plant petunias at the clubhouse,
or conduct the Rocking Chair Band with a tack hammer.
It was all a bonus,
for I knew my time was short.

If you look up into the sky,
you will see me waving to you as I fly along in the clouds
on my Golden Motorbike.

Methuselah

The Grannies and Mary rushed to the window,
looked up into the clouds and waved, saying:
"What a courageous and wonderful Leader!"
"She lived her life to the last drop!"
"What an extraordinary story!"

As they came back to the table,
Able Mabel queried:
"But how did she know we would carry out her instructions?"

"She didn't," said Mary,
"but she always liked to be prepared."

Over a last cup of tea,
the Grannies carefully added Methuselah's story to the pile.

Iris: "Now we have the entire manuscript
and can print it out on a Laser Printer."
Poppy: "And give copies to our families."

Big Bertha: "So they will know how to keep up with the world,
just like we have."

The Witch: "One day, when they feel like fossils,
or dinosaurs, or leftovers,
they too will be prepared."

Greta: "By that time, *flying* motorcycles will have been invented."

Able Mabel: "Too dangerous!"

Mary just smiled, for she loved her Grannies.
"I'll let you know as I fly past your clouds on my Flying Machine.
Watch me wave!"

And they all clapped.

Together they cried:
"Let's go to the clubhouse tomorrow
and polish our motorbikes
after their long winter rest,
and celebrate the arrival of spring."

"But only if the weather is fine," said Able Mabel.

"Be sure to come to the farmhouse for tea,"
invited Mary.

"Yes!" they shouted, as they all agreed.

The End!

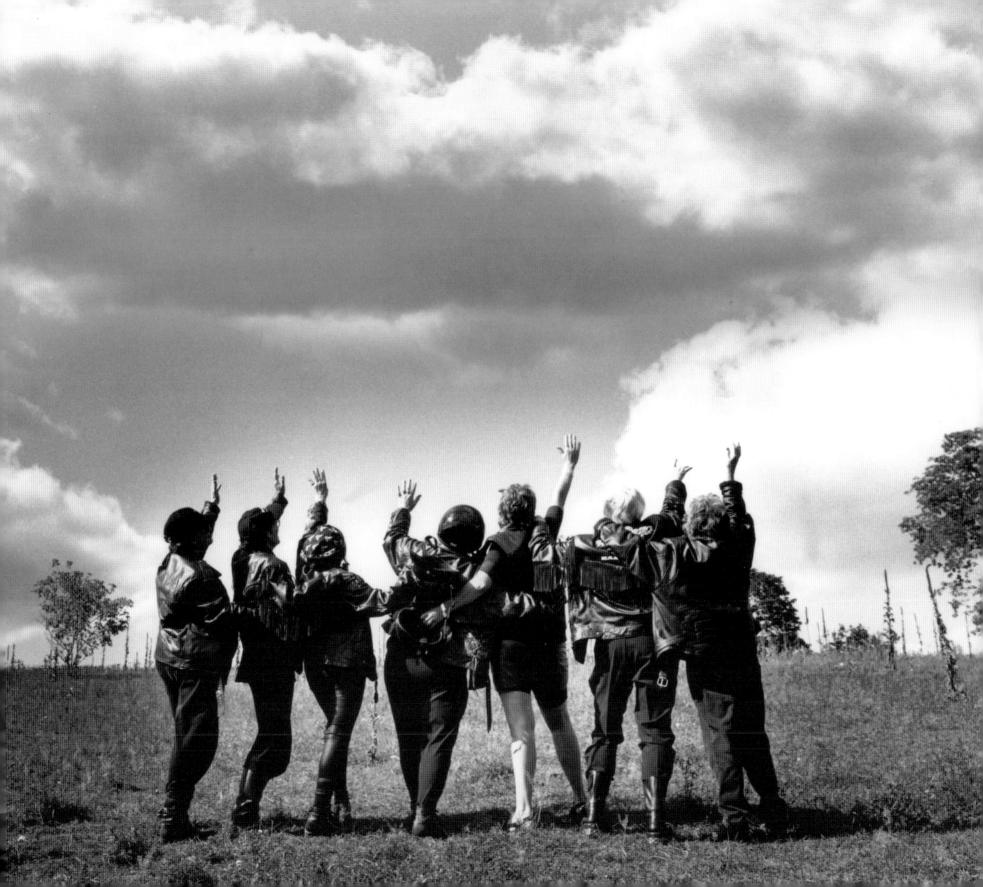

Acknowledgements

It took a big team of generous, dedicated, wonderful people to produce this book. We would like to thank them from the bottom of our hearts for all their support and the hours they gave to us.

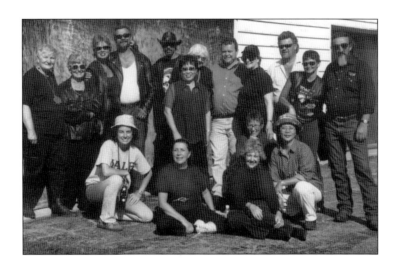

Our Grannies: Liz Avery, Betty Bradley, Betts Engell, Roberta Eustace, Ankie Gracie, Gillian McIntyre, Betty Neil, Sybil Rampen

Other "models": Kathleen Johnson and Baby Graydon Johnson, Lisa Shalton, Michelle Shalton, Terry Tillart, Jeff Thurston, Ryan McLeod, Mike Napper

Our Biker Friends: Ron Doyle and Easyriders of Ontario, Mike Napper, Darryl (Oddball) Staubaum, Dave (Cowboy) Inglis, Doug Salm, Terry (Bunga) Lyle, Peter Roglich

Our Helpers: Julie Armstrong, Puay-Lim Chang, Shen Goh, Derik Hawley, Jeff Thurston, Trina Burton, Heather Jacobs, Calvin Lacombe, Judi McLeod

Our Location Hosts: Sue Doyle of "From Roots to Bloom" in Ayr, Ontario for her barn and fabulous meals; Lynda and Glenn Osborne for their hot tub; The staff and residents of Trafalgar Lodge in Oakville for their sitting room; Mr. & Mrs. Klaus Bendex of Ayr, Ontario for their farm; St. Peter's Church, Erindale, Ontario; Wendy & Carl Cousins for their chicken farm